T0197608

LEARNING ABOUT COLOR

A Student Guide to COLOR STUDY

JOHN MCCREERY

To order additional copies of this book, contact:
Xlibris
844-714-8691
www.Xlibris.com
Orders@Xlibris.com

ISBN: Softcover 978-1-6698-5327-5
 Hardcover 978-1-6698-5328-2
 EBook 978-1-6698-5326-8

Library of Congress Control Number: 2022920219

Print information available on the last page

Rev. date: 10/29/2022

Learning about COLOR

A Student Guide to COLOR STUDY

LEARNING ABOUT COLOR

A Student Guide to COLOR STUDY

Welcome students!

This is a coloring book. But with a difference! Here students of nature and art can compare their choices of color, shade, shadow, and line with beautiful images from nature. This book uses the method of the old masters as they instructed apprentices through practice, duplication, and repetition to achieve mastery of a medium. Review the instructions on page 2 and begin experimenting!

This book is suitable for all ages. It is the hope of the author that use of it will bring increased skill at representation and an appreciation for nature's subtlety and beauty.

Enjoy it!

John McCreery

How to use this book:

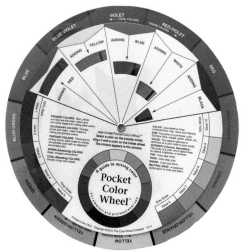

Things you need:

1. This Book!

2. A comfortable *stable* table upon which to work/draw. Adequate *light* on the drawing surface.

3. Drawing supplies! Get a color wheel! It will help you match and select colors. Select colored pencil and pastel color sets from those available to you.

4. Time to draw. Give yourself lots of time to study the images and make choices before and while you draw.

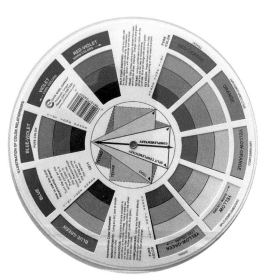

Front Back

2

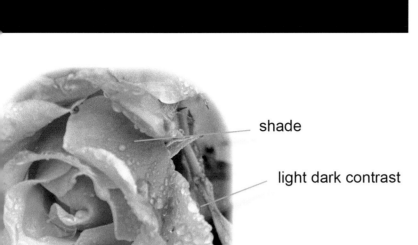

shade

light dark contrast

color contrast

Things to know:

1. Informing perception:

There is a difference between what *we think* we see and what *we actually see*!

We may *think* a flower is pink, but it may be a combination of colors. What we see is all these colors and the effects on them of place- which is: where they are in relationship to their surroundings.

2. Color:
Not all colors that we see are represented in our pencil sets! To make additional colors a color wheel is a useful tool. Combinations of primary and secondary colors can combine to make a third color.

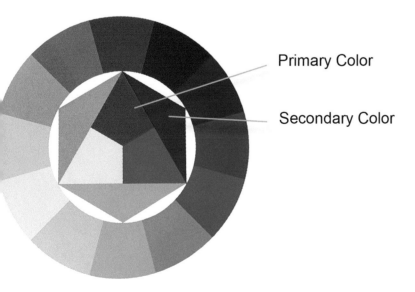

Primary Color

Secondary Color

For instance: Look at the color wheel to the left. Notice the three primaries in the center: Red, Yellow, and Blue. Combining Red and Blue, we get Purple! Combining Red and Yellow; we get the Secondary Color, Orange. For instance: Look at the color wheel to the left. Notice the three primaries in the center: Red, Yellow, and Blue. Combining Red and Blue, we get Purple! Combining Red and Yellow; we get the Secondary Color, Orange. By adding white or black, we can change the lightness or darkness of the color. This is called changing the color "value."

Use the color wheel to find combinations that add up to the color you are seeking. The masters spend a lot of time on this activity. Experiment!

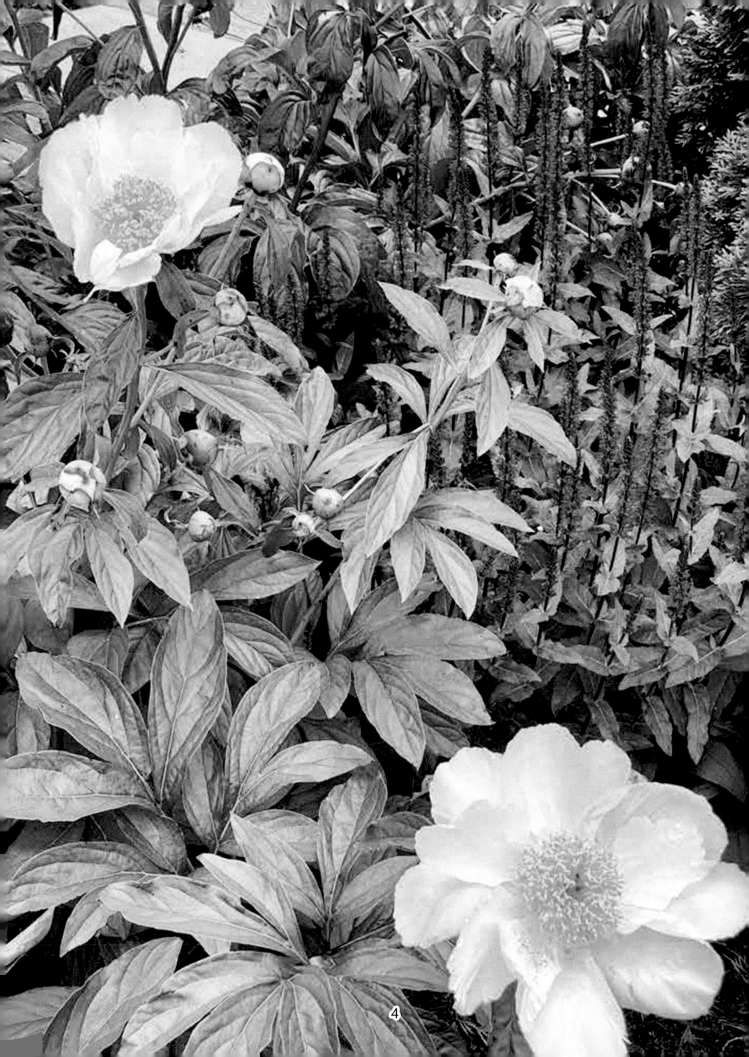

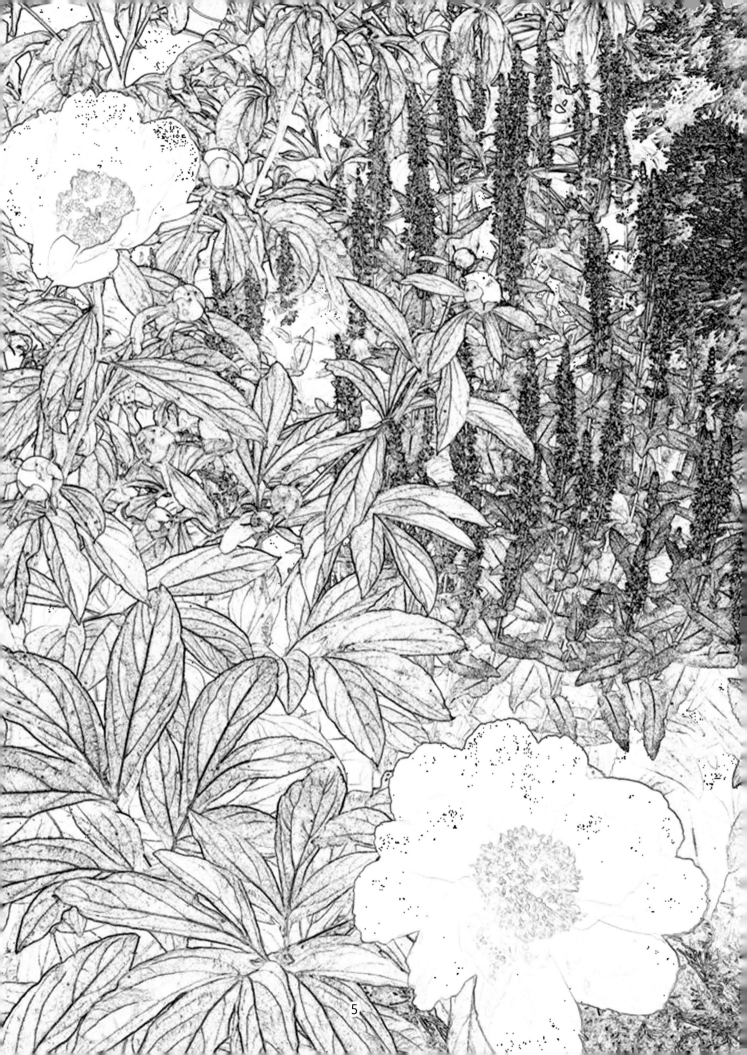

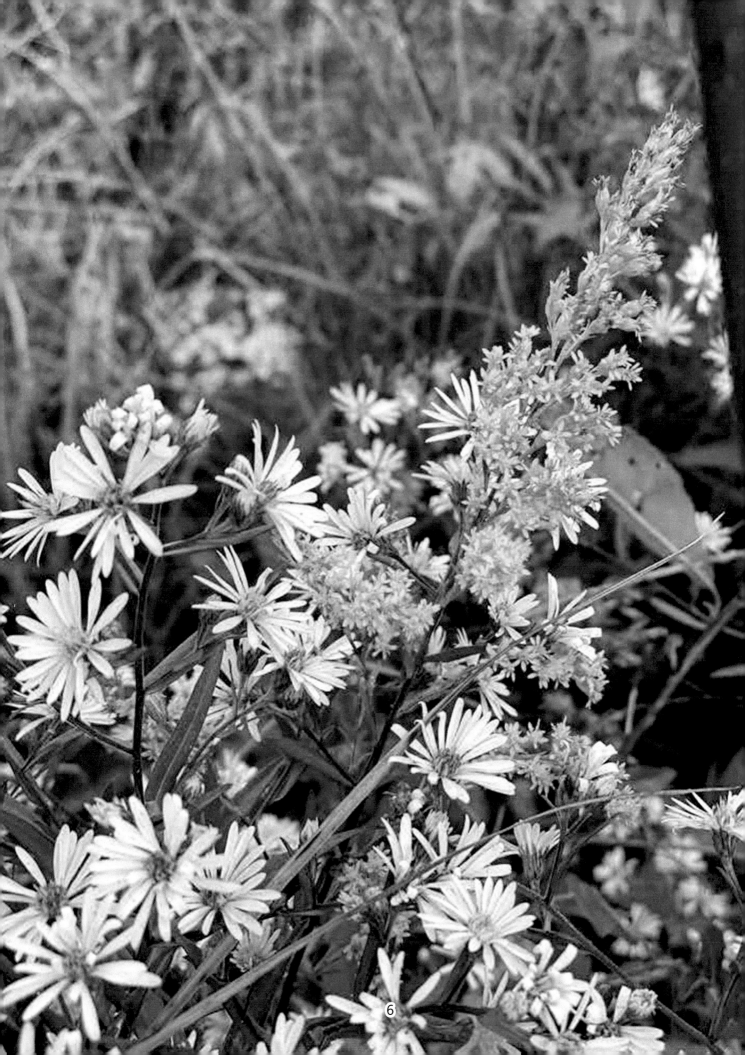

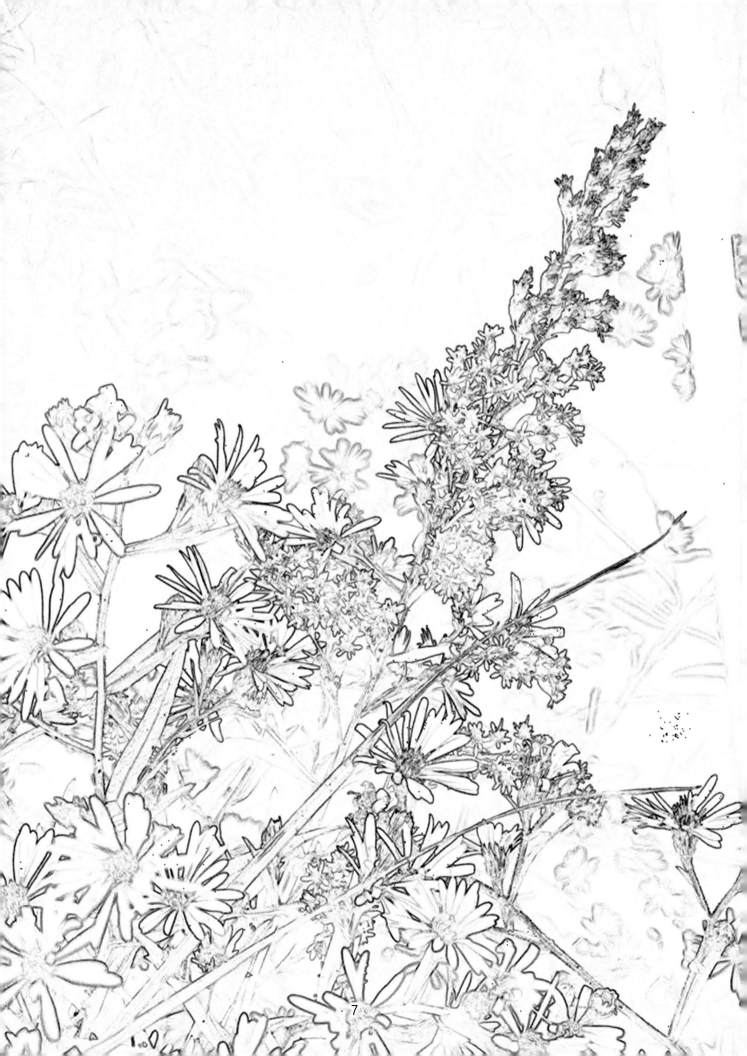

7

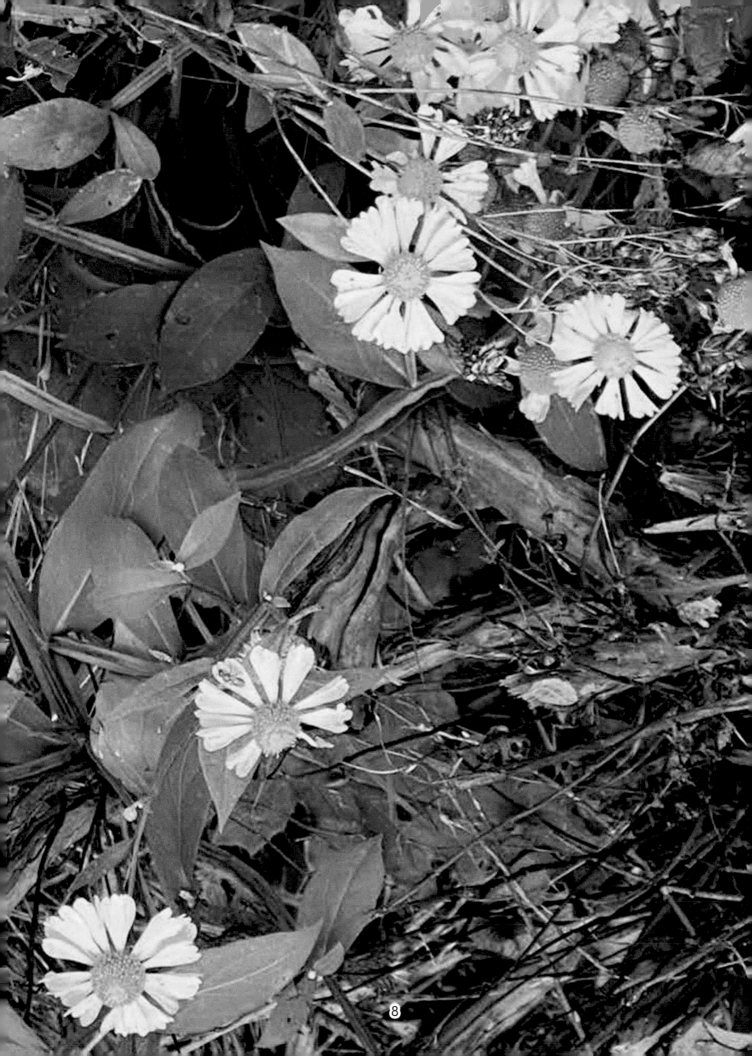

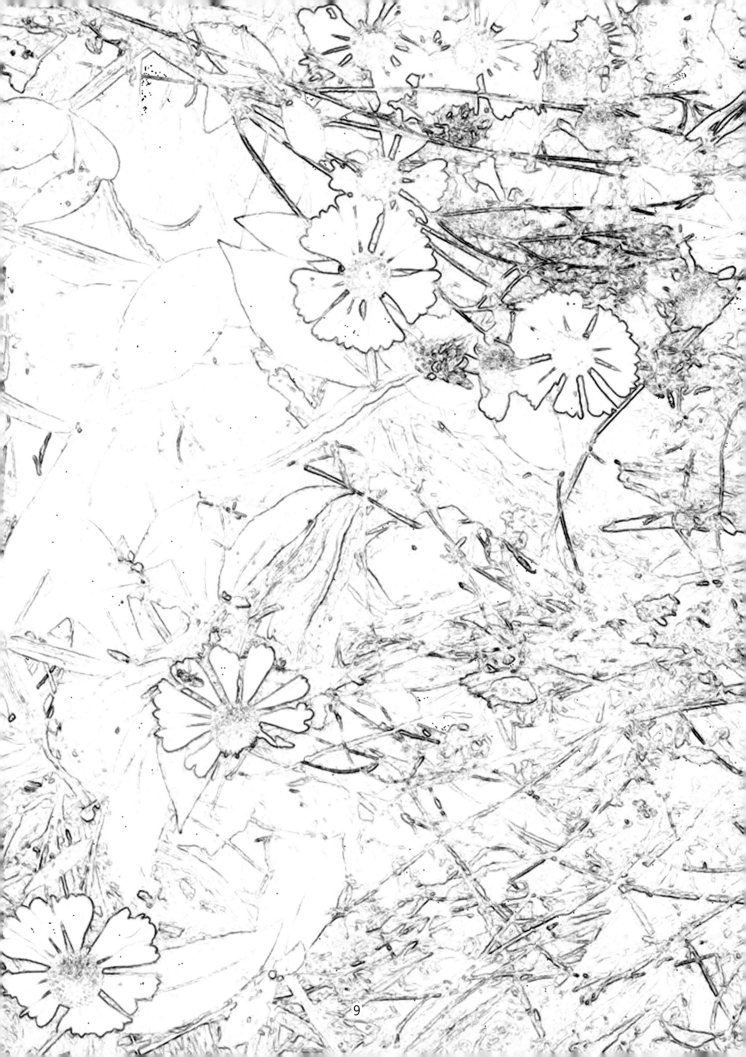

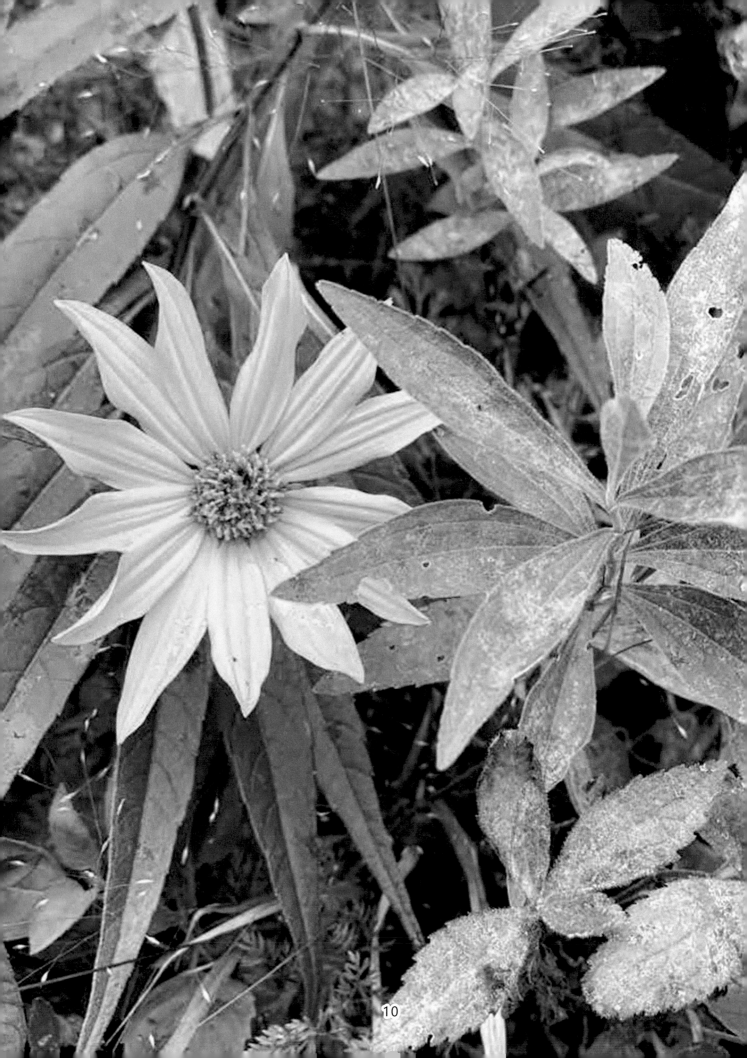

10

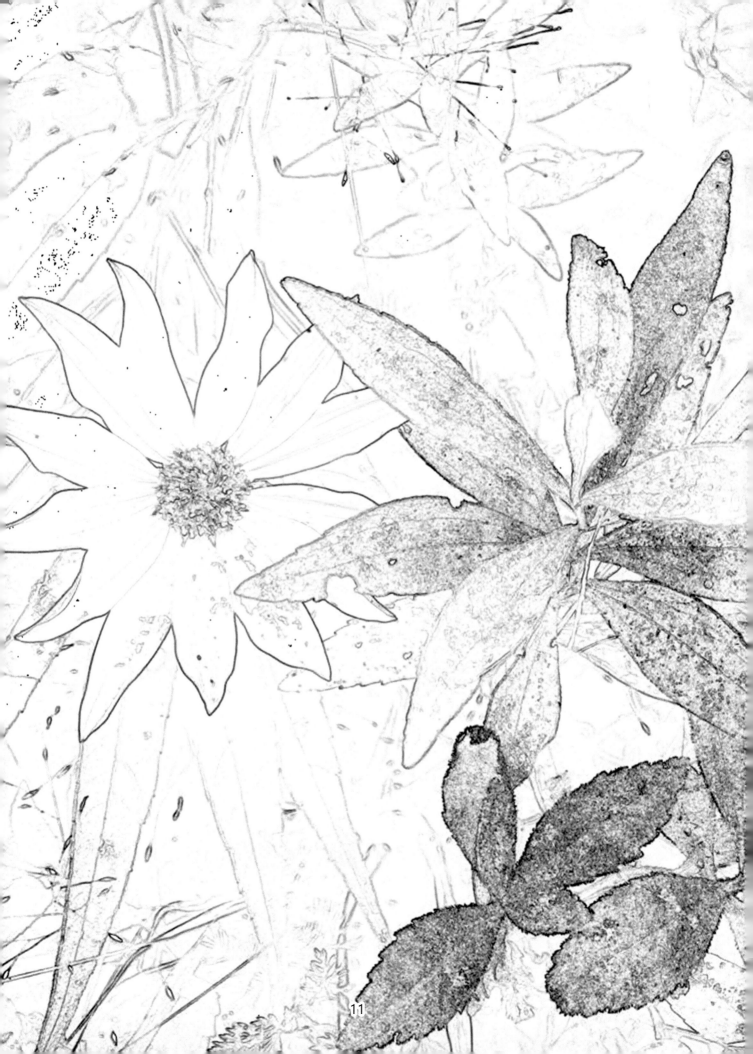

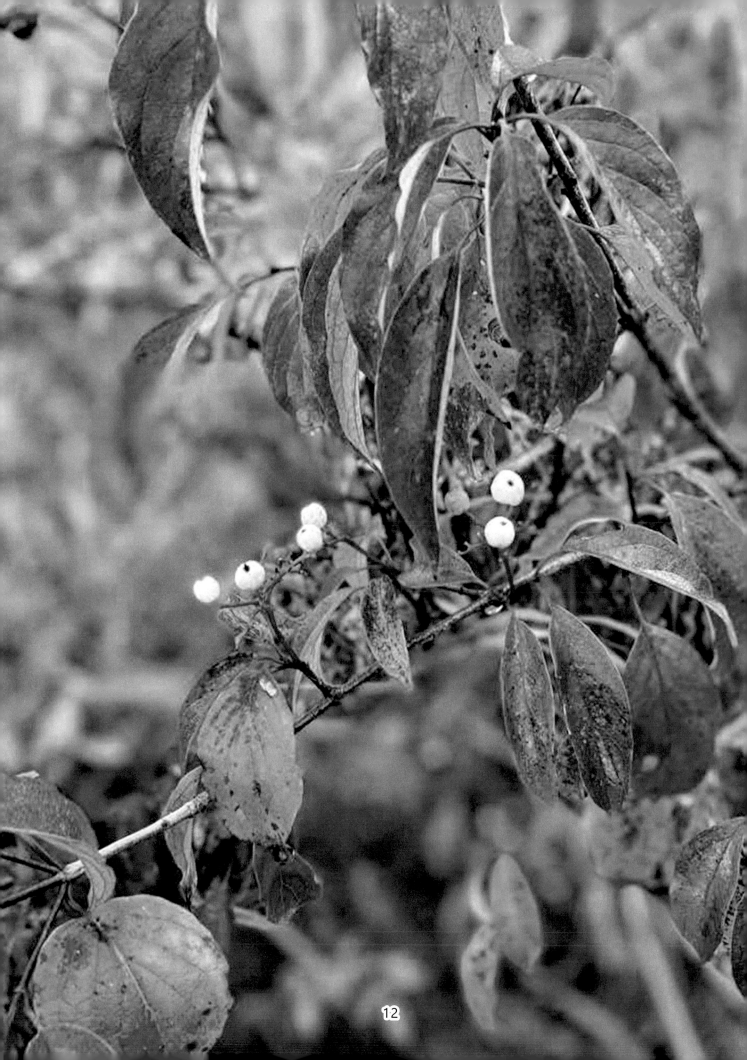

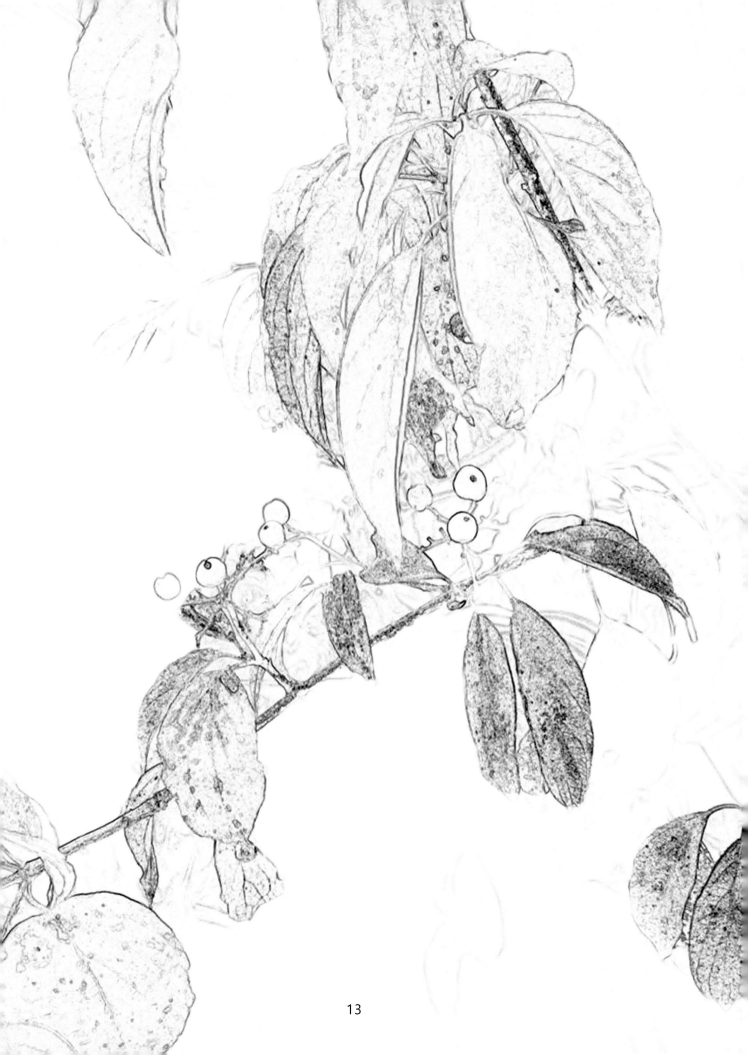

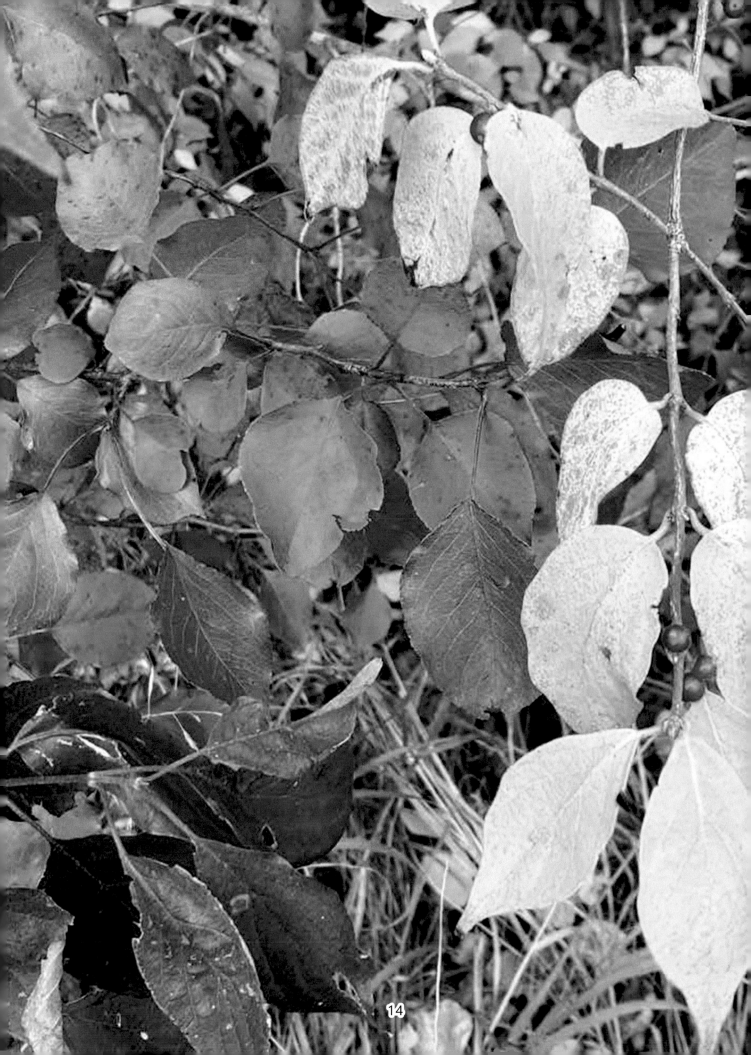

14

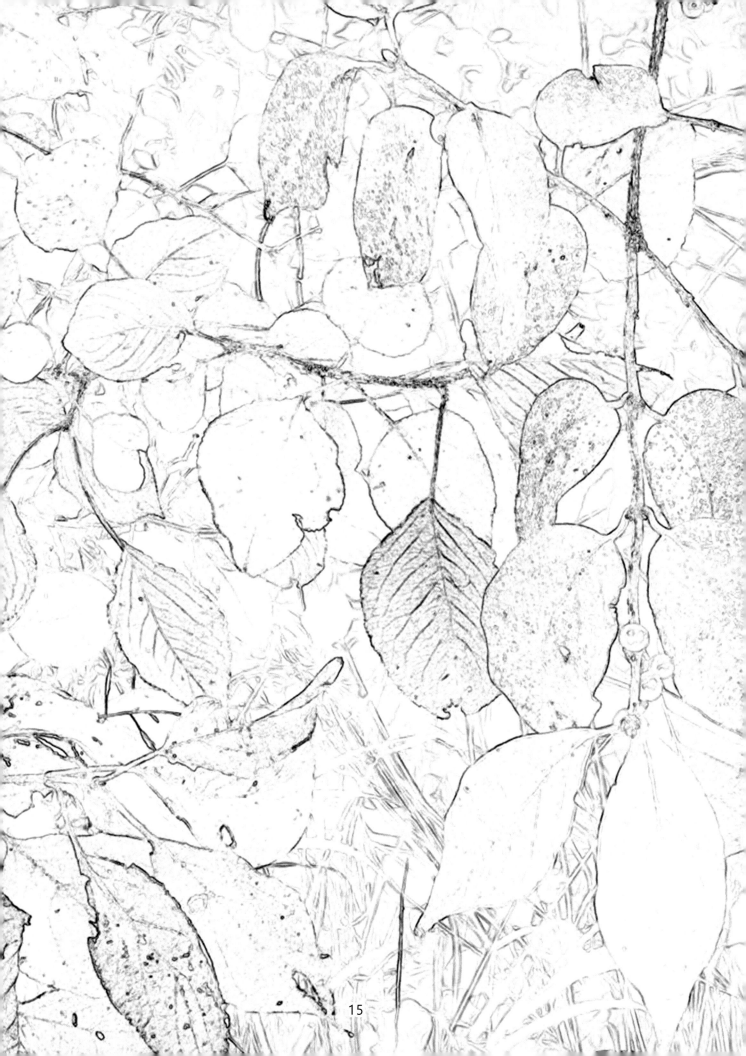

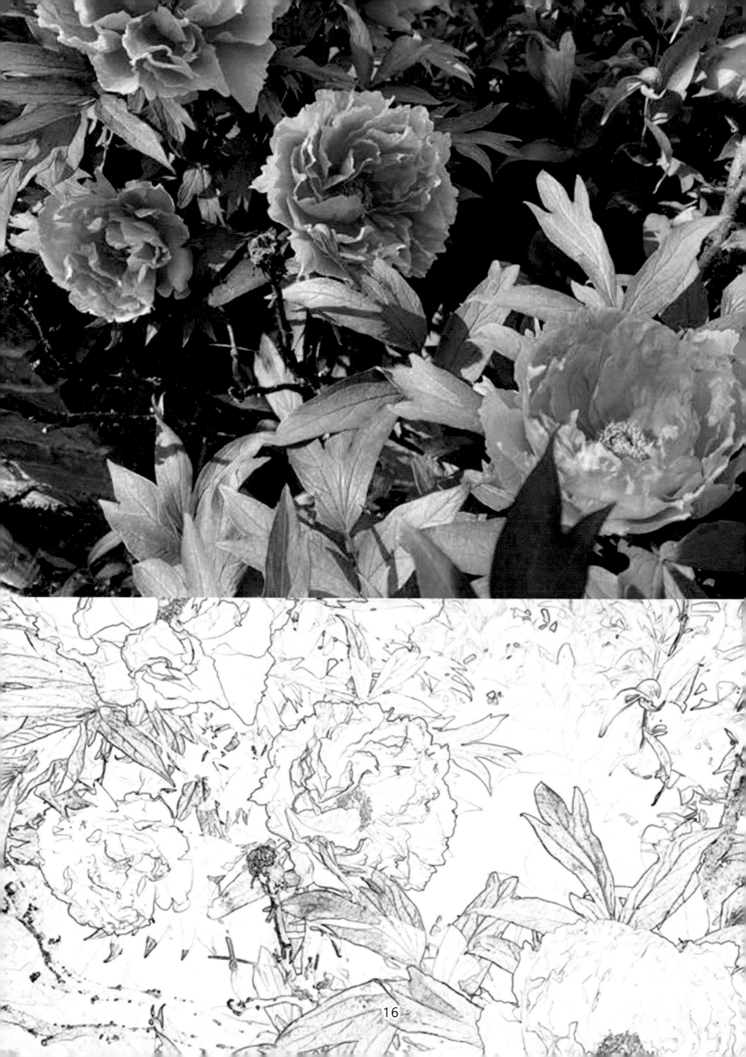

16

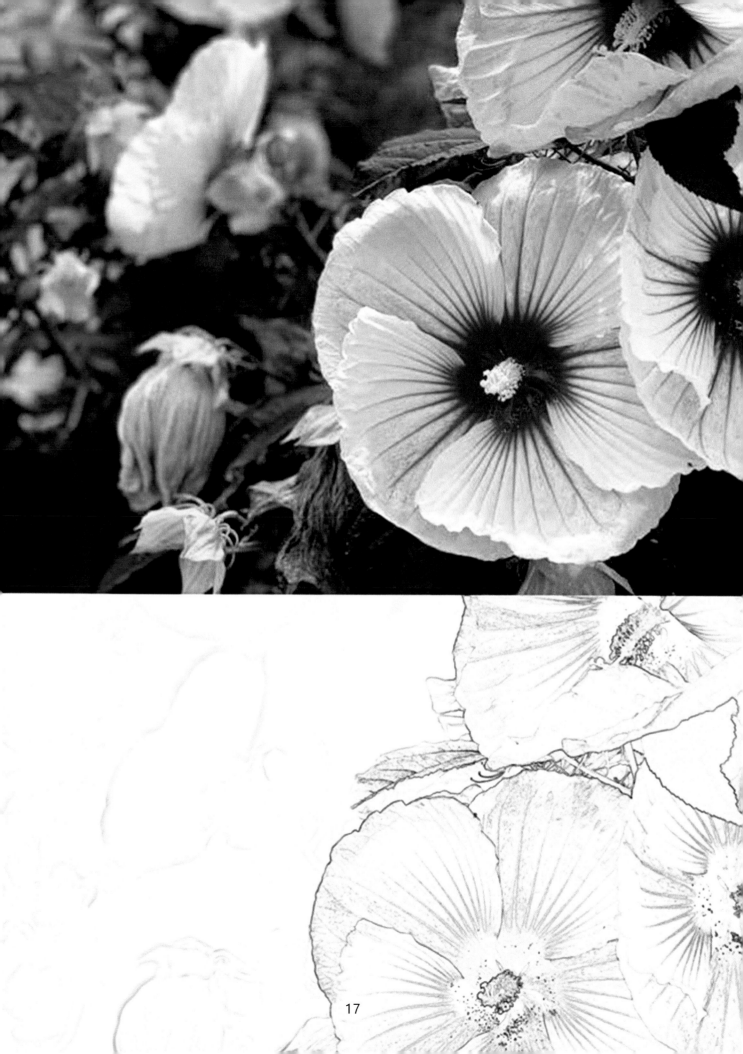

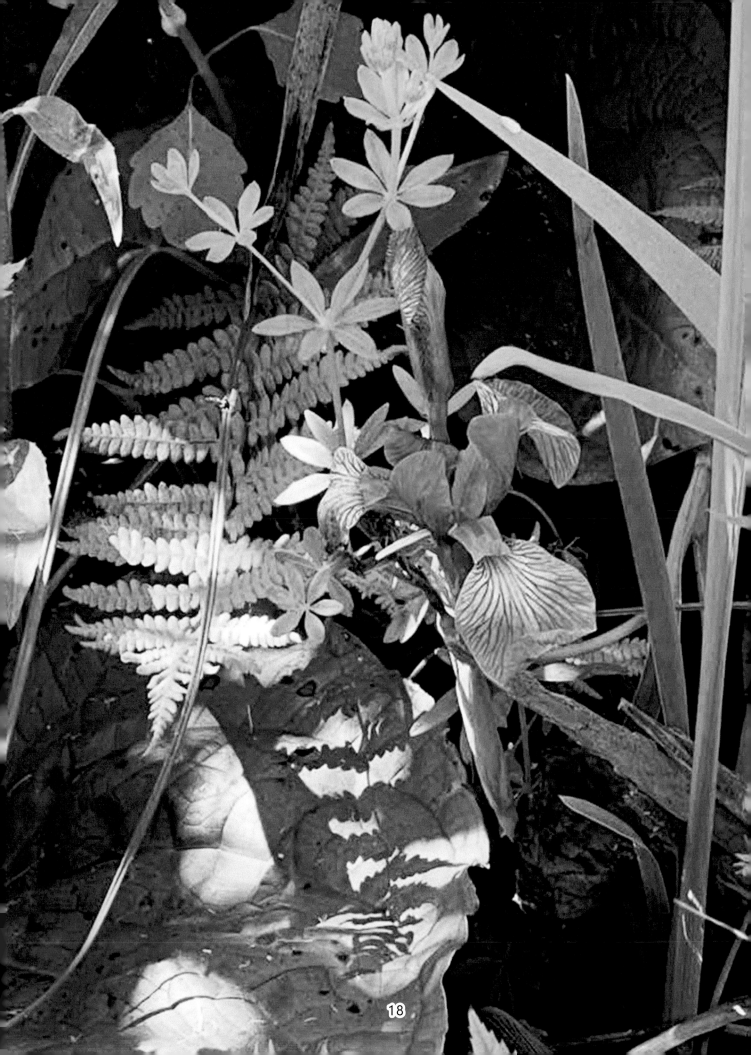

18

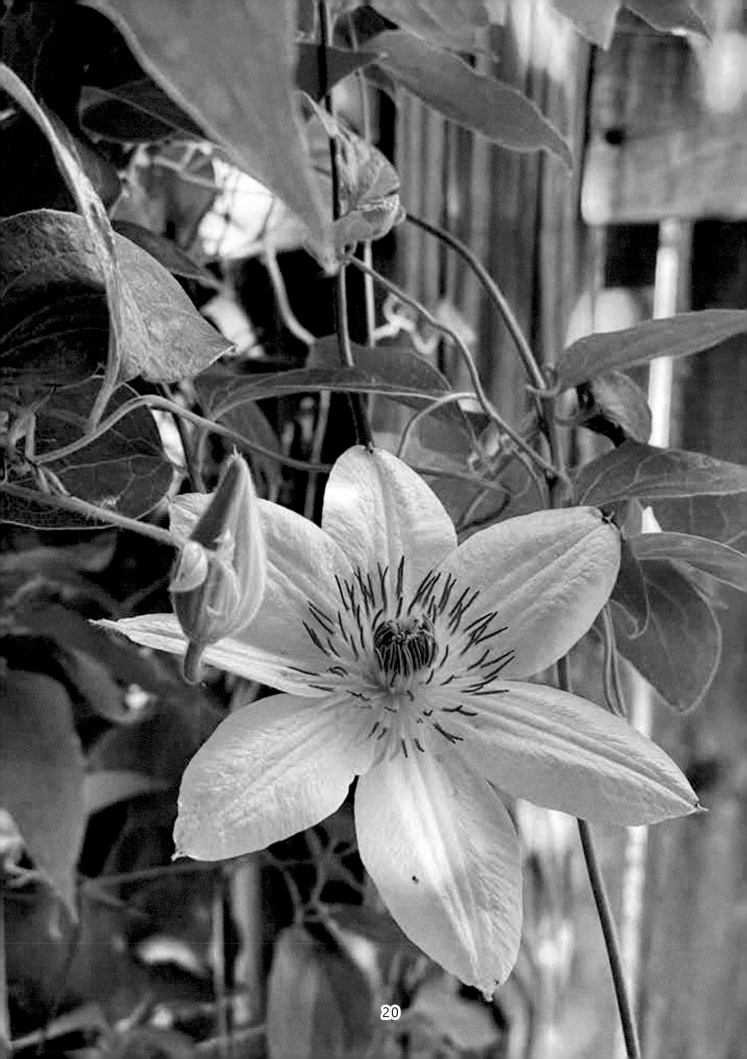

21

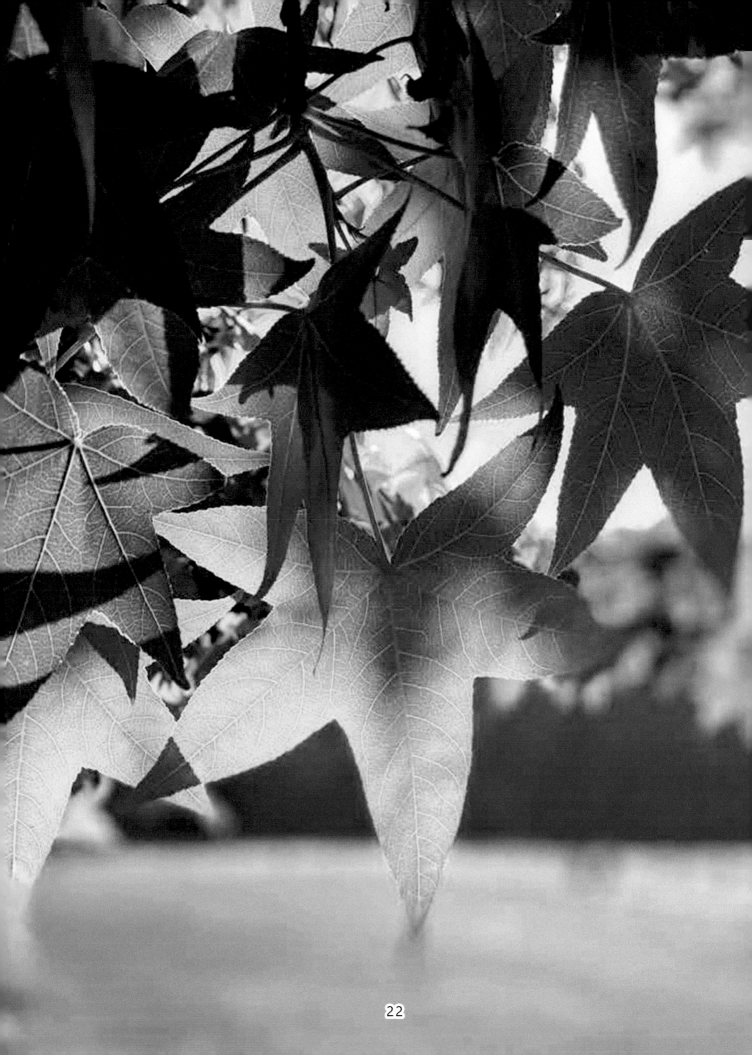

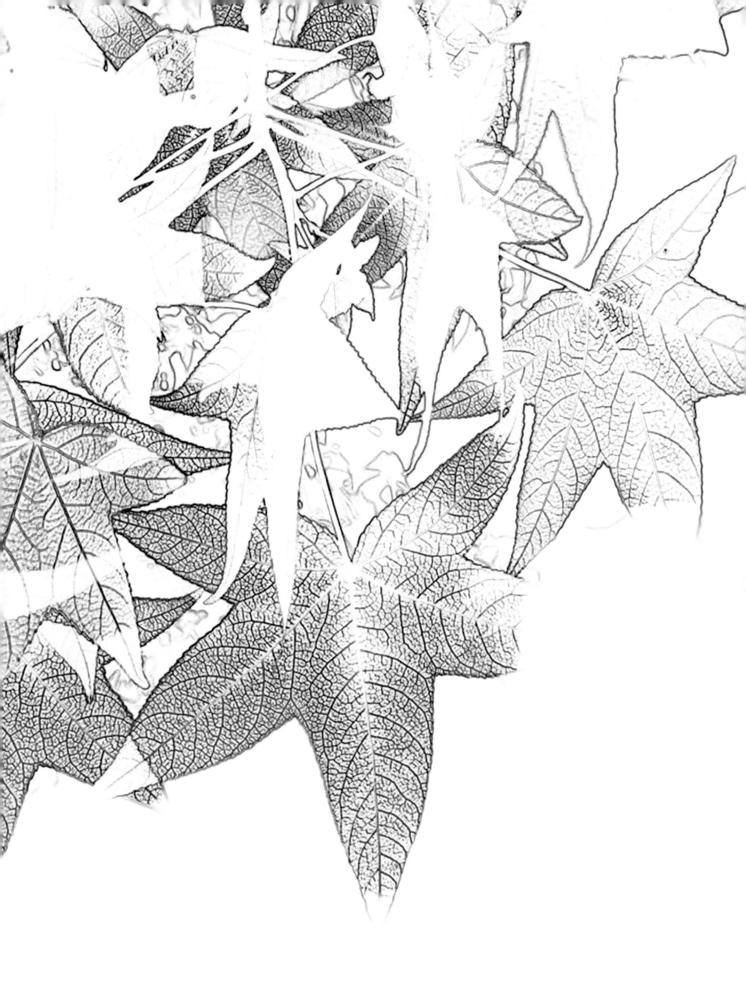

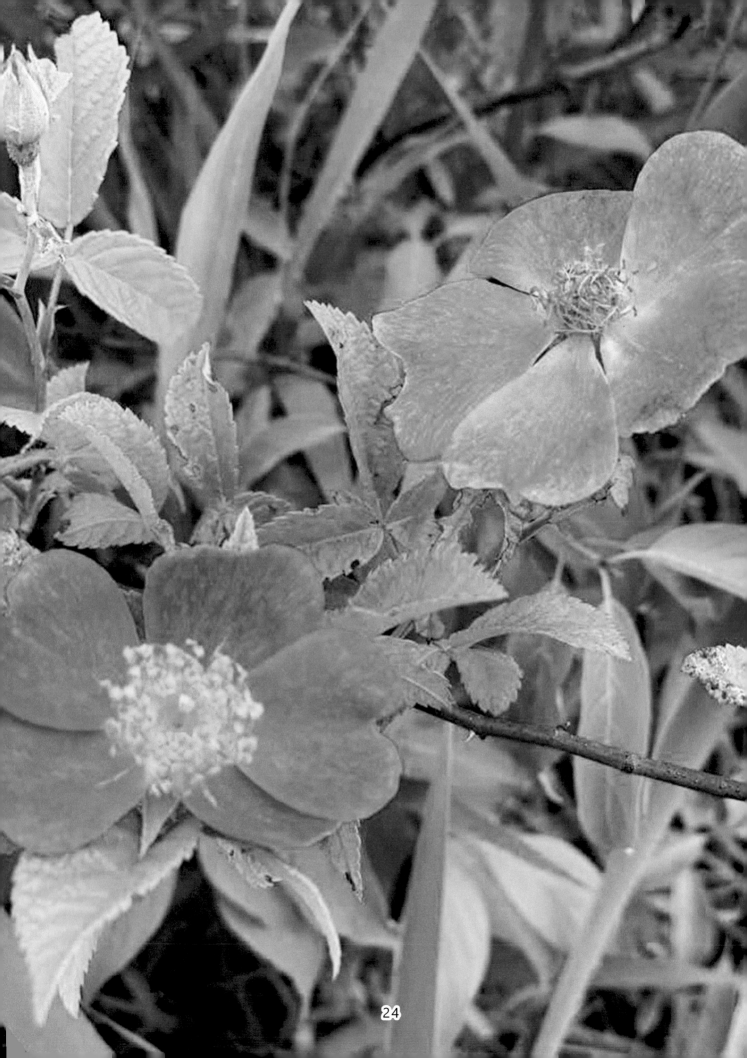

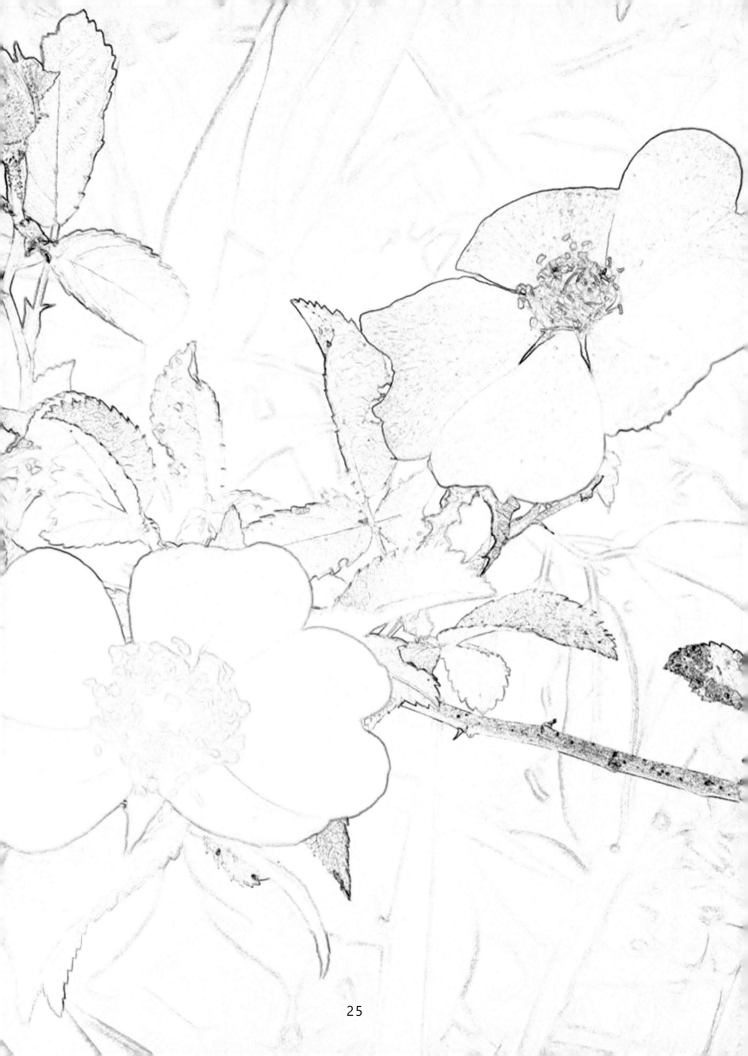

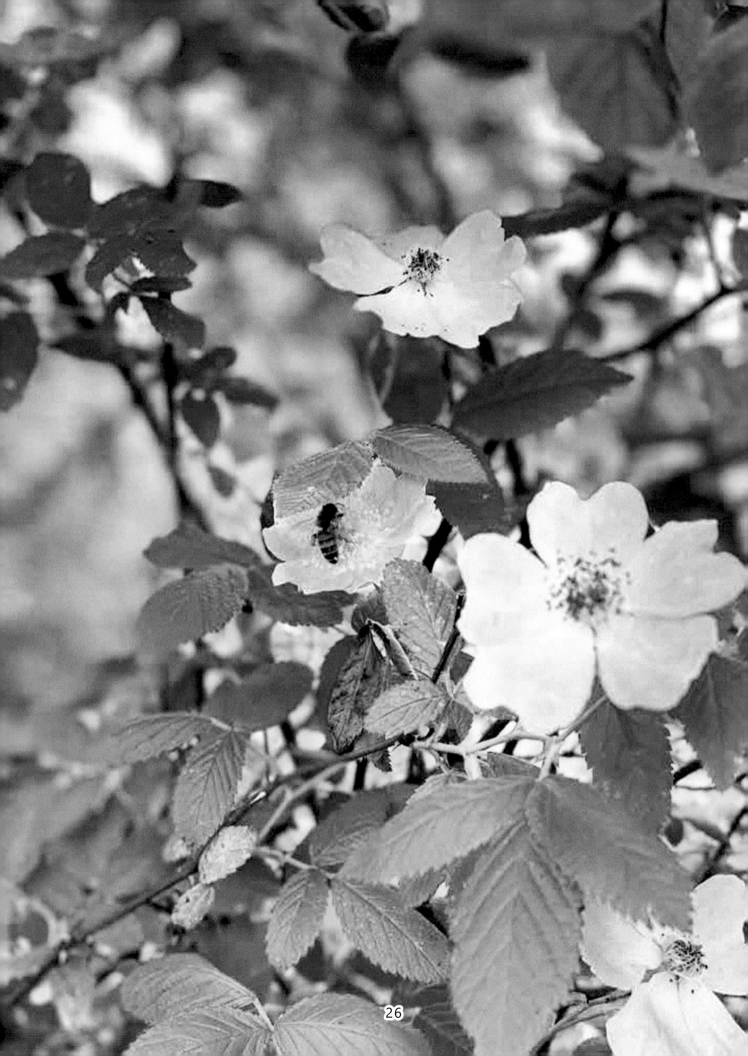

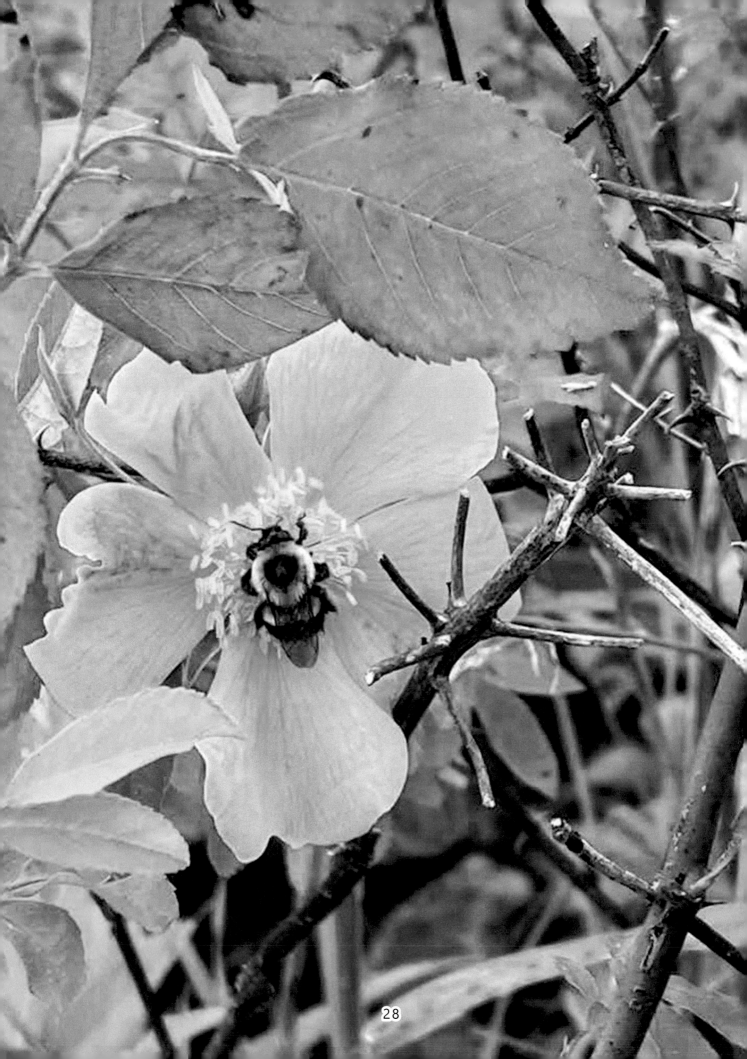

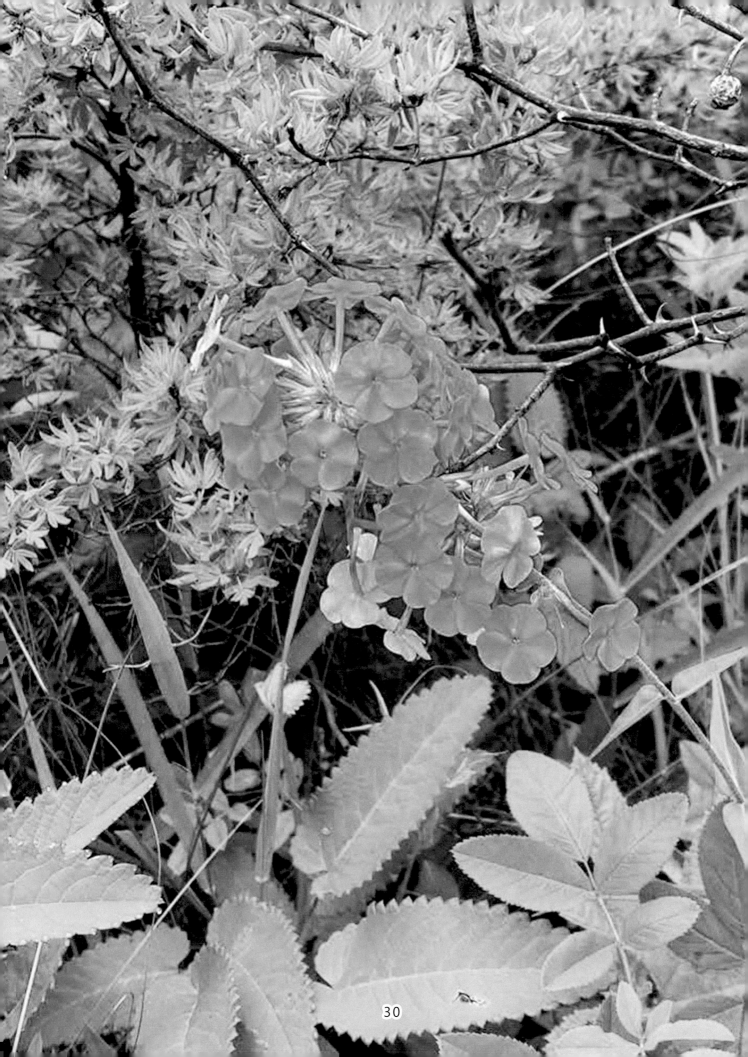

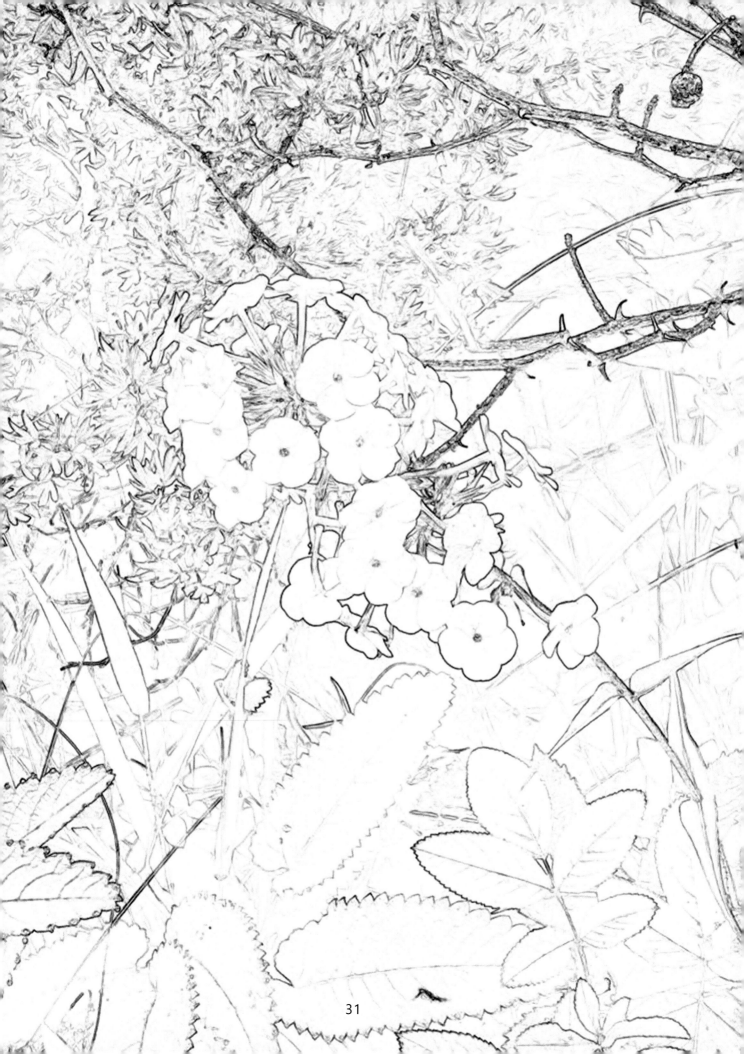

31

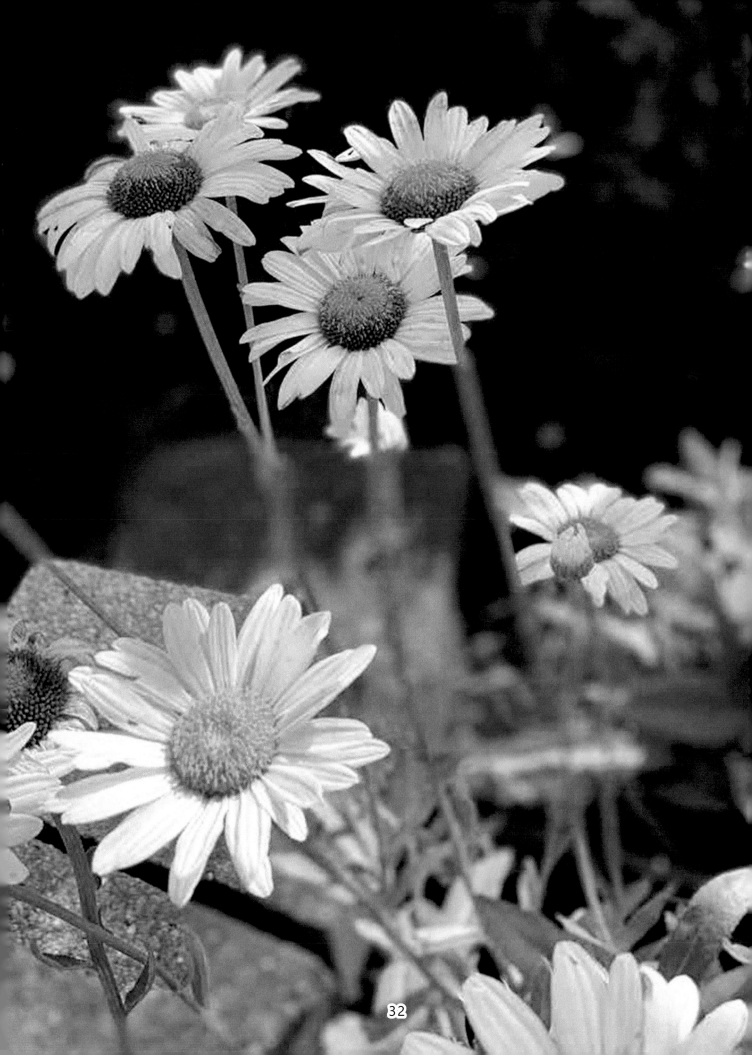

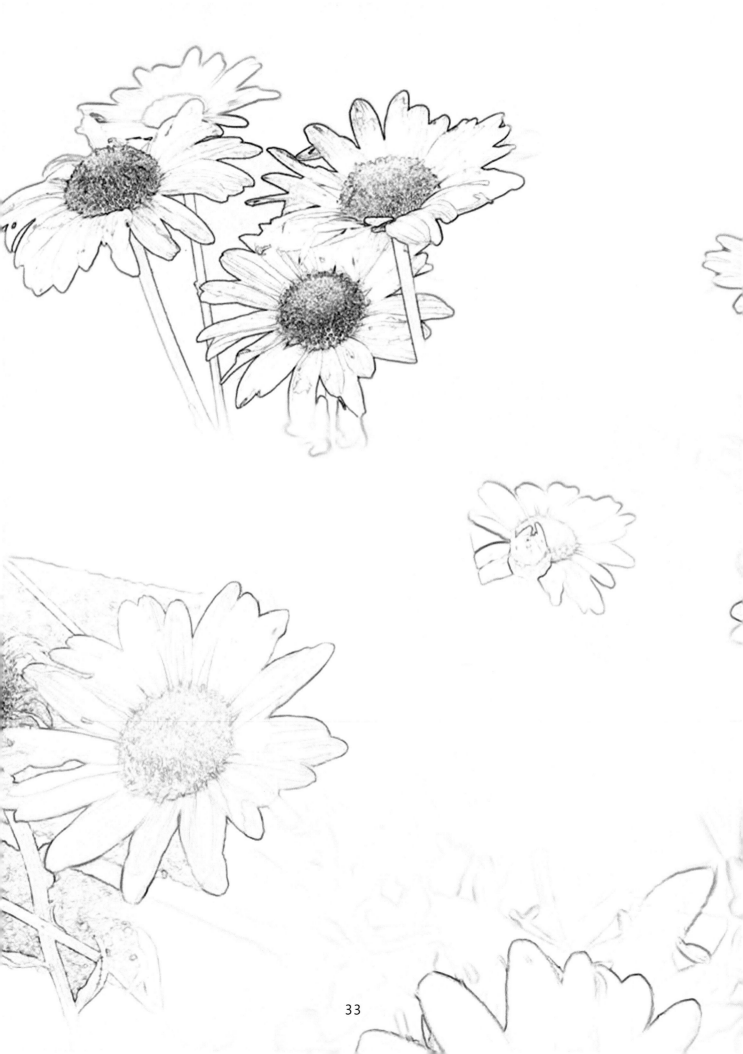

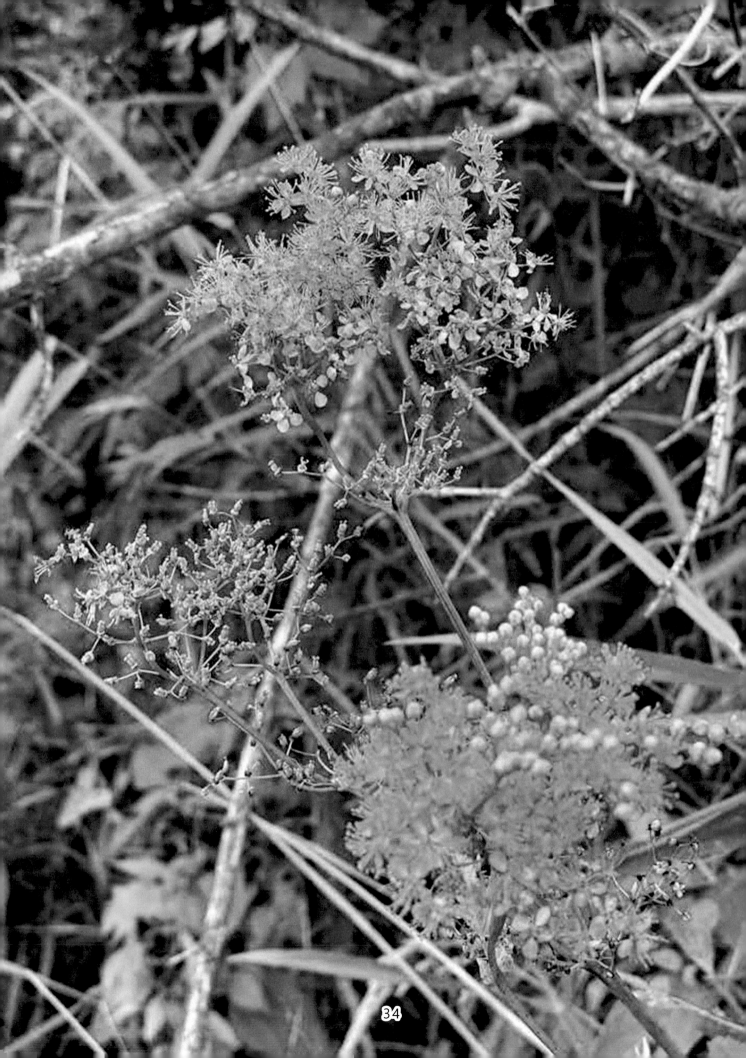

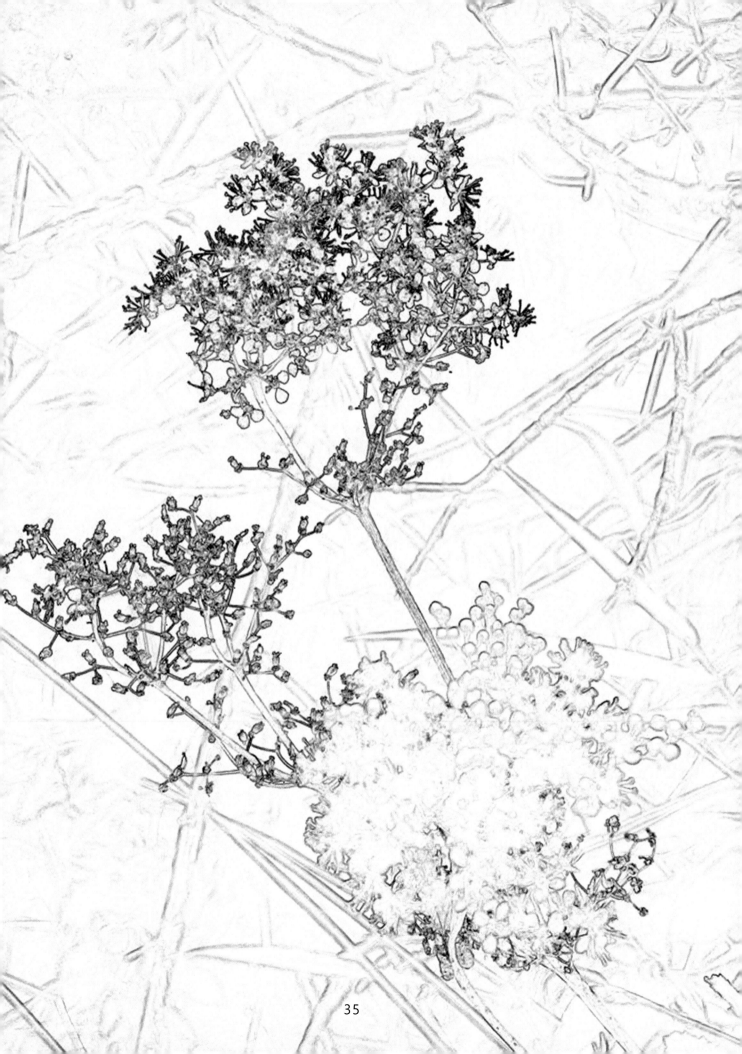

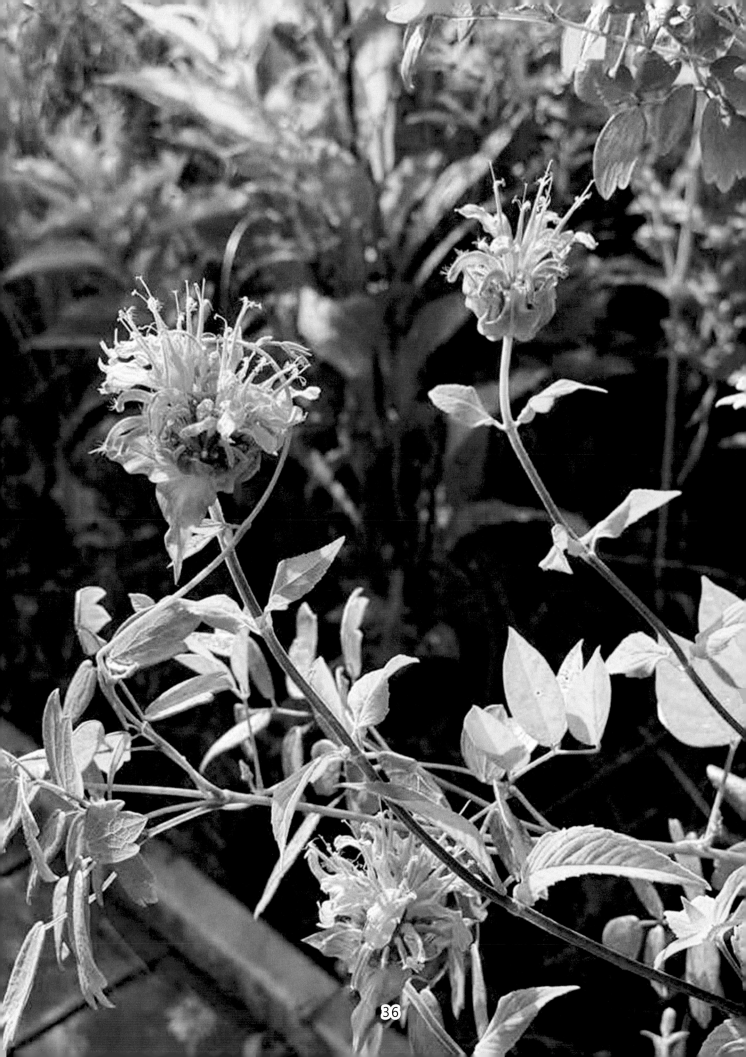

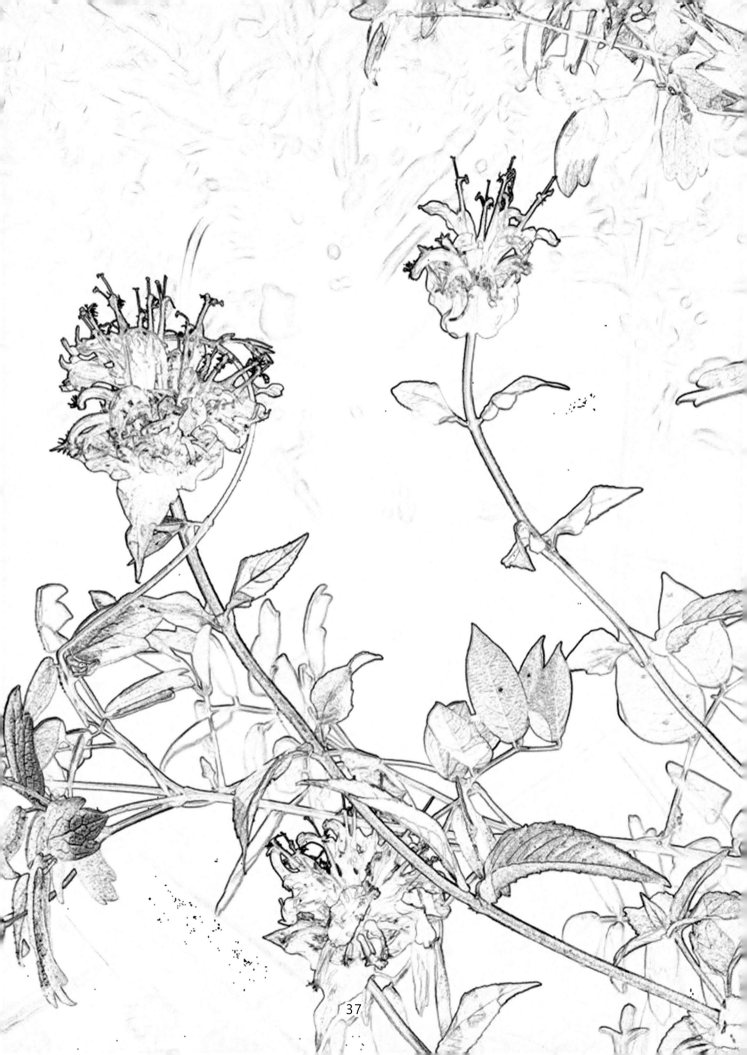

Printed in the United States
by Baker & Taylor Publisher Services